IMAGES
of Modern America

VETTER HEALTH SERVICES

Blessings
Eldora ~ Jack

MORE THAN WORDS. Jack and Eldora Vetter's chosen path to serve the elderly through a mission of providing *dignity in life* gives purpose to everything they—and all Vetter Health Services team members—do. It also challenges others to determine their own paths and decide what *dignity in life* means to them.

ON THE FRONT COVER: Fashions may change, but personalized care and activities that bring the generations together never go out of style, as depicted in these photographs taken throughout the years at several Vetter Health Services (VHS) facilities. In a 1989 image at center left, VHS facility resident Cecile White and VHS Founder Jack Vetter are pictured more than 45 years after they met as teacher and student at a Bassett, Nebraska, one-room country school. Jack and Cecile epitomize the emphasis on relationships that is the heart of the enduring VHS mission. (Photographs courtesy of Vetter Health Services.)

ON THE BACK COVER: Jack and Eldora Vetter (photograph to the right) began Vetter Health Services in 1975 with the belief that elderly people deserve *dignity in life*. Four decades later, what began as the couple's personal mission has grown to include more than 30 award-winning senior care facilities that are home to 2,200 residents and patients who are cared for by 3,500 team members. Based in Elkhorn, Nebraska, VHS is recognized as a national leader in providing safe, comfortable, and happy senior living centers. Each facility is built around the individual needs of residents and their community; every aspect of care and operation is shaped by the VHS mission, vision, and values. Support and expertise are always available from administrators and team members who share Jack and Eldora Vetter's heart for service and passion for excellence. Together, they are changing the view of long-term care for senior citizens. (Photographs courtesy of Vetter Health Services.)

IMAGES

of Modern America

VETTER HEALTH SERVICES

DaNita Naimoli and Diane Neal

ARCADIA
PUBLISHING

Published by Arcadia Publishing
Charleston, South Carolina

Printed in the United States of America

Library of Congress Control Number: 2014952053

For all general information, please contact Arcadia Publishing:
Telephone 843-853-2070
Fax 843-853-0044
E-mail sales@arcadiapublishing.com
For customer service and orders:
Toll-Free 1-888-313-2665

Visit us on the Internet at www.arcadiapublishing.com

*Dedicated with love and gratitude to our family, each
resident, team member, quality partner, and friend
who has shared in our incredible journey.*

—Jack and Eldora Vetter

CONTENTS

ACKNOWLEDGMENTS

When we talk with residents and team members in any Vetter Health Services (VHS) setting, we see warmth, friendship, laughter, and beauty that speak of home to every unique person who lives with us. We provide the welcoming environment with tasteful decor, delicious meals, and fun activities, plus the compassionate care and companionship of exceptional professional caregivers. But the spirit of life comes from our residents. Their needs and expectations give us the reason for our existence. Without them, there would be no Vetter Health Services.

Many years ago, we embraced a personal mission to give the elderly members of our community a place to feel respected, secure, comfortable, and happy. It is what they deserve after giving so much of themselves. Today, our mission has become a very real and active guide representing values held deeply and honestly by every member of our team, from facility to home office—and it shows in the practical things we do each day. We captured these ideas in a mission statement, a series of vision statements, and a written list of values that truly are the foundation of everything we do. They are distributed to new residents, families, and team members. They are referred to constantly as reminders that our actions and words should uplift each resident as a valued individual, a member of our family worthy of our love and respect. This book shares more about the VHS mission of care and demonstrates the many ways it comes alive through actual examples.

We extend our sincere thanks to our family, all of our residents, and our VHS team members and quality partners for allowing us to live out our mission every day. To our children, Denny, Vicki, and Todd, your service to VHS as board members and beyond has helped to shape the company and is a source of pleasure and pride. Special thanks also go to Julie Knobbe, whose commitment and dedicated service to VHS began in 1980 and continues to this day. We must also acknowledge Glenn Van Ekeren and Mitch Elliott, without whose input, time, energy, and talent, this book—and today's Vetter Health Services—could not have happened. We extend our gratitude to them and to the many, many serving hearts with whom we have been honored to work over the past 40 years.

Unless otherwise noted, all images appear courtesy of Vetter Health Services.

With warm regards and a sincere commitment to service,
Jack and Eldora Vetter, Founders

INTRODUCTION

Before I formed you in the womb I knew you, before you were born I set you apart.

—Jeremiah 1:5

When Jack Vetter signed the agreement to buy his first nursing home, he had no way of knowing he was taking the first step in a journey that would change the view of long-term care for senior citizens.

This book traces the first 40 years of that journey in pictures and in words. Stories from Jack and Eldora Vetter's youth lay the foundation for what would become their life's work, providing quality care for senior citizens—from the 1975 purchase of Heritage of Fairbury, located in Fairbury, Nebraska, to more than 30 Vetter Health Services senior care centers and more than 3,500 VHS team members whose commitment to service is redefining the meaning of "nursing home."

This project chronicles the growth of a company that puts the happiness and comfort of its residents first, and describes how the enduring VHS mission of providing *dignity in life* strives to provide everything residents of VHS facilities need—physically, emotionally, and spiritually—to feel respected, fulfilled, useful, healthy, and secure.

As Jack continually reminds the VHS team, "I'm never satisfied with status quo. The best isn't good enough. We want to be better than the best. We strive to be world class. Every minute of every day we have the privilege, opportunity, and responsibility to revitalize people's view of long-term care. . . . We understand that other people do what we do. We just want to do it in a way that no one else is doing."

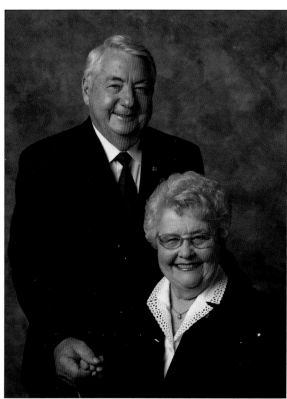

JACK AND ELDORA VETTER, 2004. Jack and Eldora Vetter's desire to serve others sparked the Vetter Health Services mission of *dignity in life*.

THE VETTER FAMILY, 1975. Before the VHS mission came to be, two young people believed that strong faith and hard work would guide them to God's purpose for their lives. Before "the Vetter way" made a difference in the lives of thousands of residents and team members, relationships, experiences, and events illuminated Jack and Eldora's path, one step at a time. They are pictured here with their children (from left to right) Denny, Todd, and Vicki.

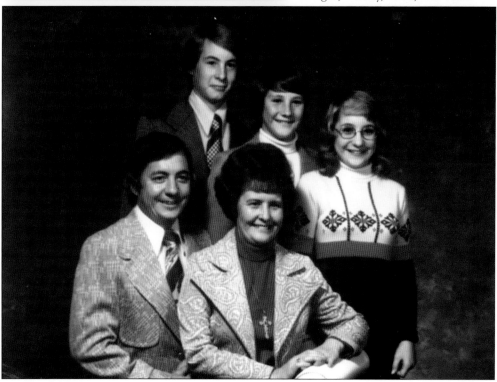

One

PILLARS TO
LIGHT THE WAY

*Trust in the Lord with all your heart and lean not on your own understanding; in
all your ways acknowledge Him, and He will make your paths straight.*

—Proverbs 3:5–6

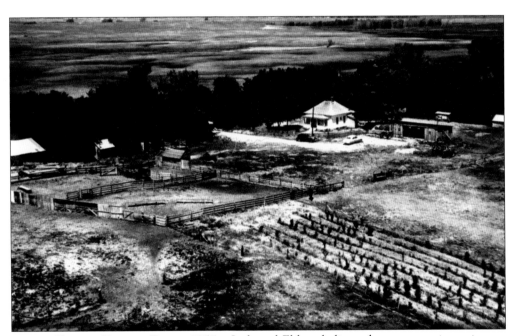

VIRGLE VETTER RANCH, EARLY 1950s. Jack and Eldora believe that no experience is ever
wasted—all are part of God's plan. The early years helped prepare them for the future. For Jack,
this meant learning the meaning of an honest day's work on his father's ranch. No one would
have guessed that these humble beginnings were the perfect foundation for enriching thousands
of lives. This ranch is still owned by the Vetter family.

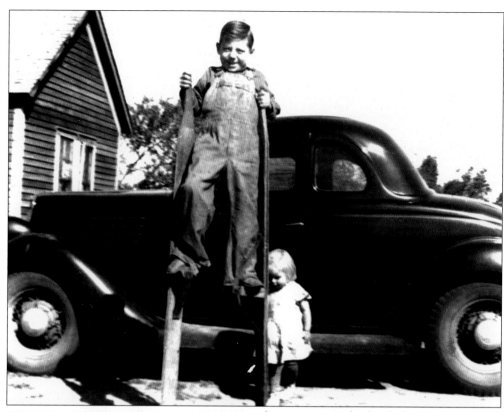

STARGAZING. Jack's family lived on several farmsteads when he was growing up. His first home was in Riverview, Nebraska, in the Niobrara River Valley. The Vetter family lived in a log house without electricity or running water. At night, if he positioned himself just right, Jack could lie in bed and see the stars through a gap in the wood. Here, Jack and younger sister Getha show off homemade stilts.

THE SLIDE STACKER. Jack liked to dream about building things, and he often turned his ideas into reality. When he was a young boy, he came up with a working replica of his father's slide hay stacker. Jack made it from scraps of lumber, without help from anyone. It was the first of many things he would build. He is pictured here at age 10 with sister Getha and the slide stacker in 1944.

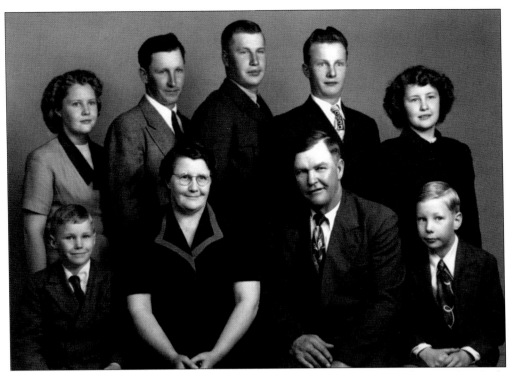

Scraps of Wood, Strips of Cloth. Eldora Arent was growing up just 30 miles away from Jack, on a ranch between Ainsworth and Johnstown, Nebraska. She, her five brothers, and her sister shared everything, including toys they dreamed up and created from odds and ends. Arent family members pictured here in 1953 are, from left to right, (first row) Lyle, Effie, Herman, and Alvin; (second row) Elaine, Leslie, Robert (Bob), Howard, and Eldora.

Simple Pleasures. The Arent family farm provided a livelihood that taught Eldora and her brothers and sisters the value of hard work and to respect and care for all of God's creatures. Eldora is shown here with her older brother Bob.

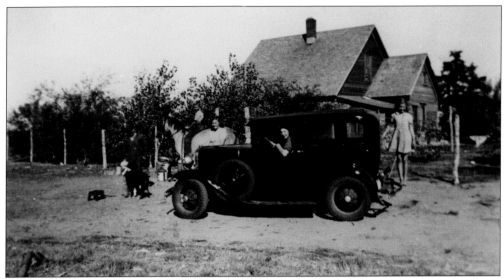

Strong Roots and Green Shoots. The love and discipline of strong families helped guide Jack and Eldora on their path to discovering their mission. Here, Eldora (on the trailer hitch) is pictured with some of her family members at their farm.

Arent Homestead, Early 1900s. Both sets of Eldora's grandparents were homesteaders; pictured here is the Hedvig and Holger Arent homestead. Eldora's family homestead was located on the Niobrara River south of Merriman, Nebraska. Both Jack and Eldora's parents were ranchers. Hard work kept roofs over their heads and food on the table. Schooling was a priority. This upbringing helped Jack and Eldora develop the work ethic they needed to build the future Vetter Health Services facilities and management company from the ground up.

JACK VETTER WITH PARENTS, 1936.
Jack and Eldora also learned the importance of sharing what they had—whether it be time, talent, or treasure—with those in need. "There wasn't anybody Dad wouldn't help," Jack recalled of Virgle, pictured here with his wife (and Jack's mother), Neva.

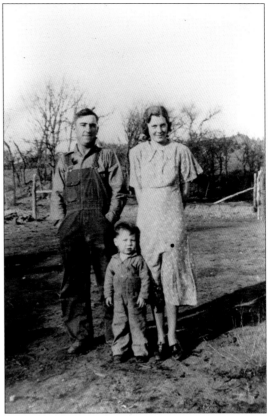

HERMAN ARENT AND EFFIE JONES, 1924.
Eldora's parents, pictured here just before their wedding, placed a similar value on giving to others. "Probably not one person in 100 grew up with parents who gave as much as they did. Dad would give his last penny to help someone else," Eldora said.

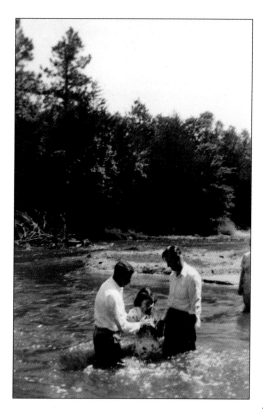

BAPTISMAL SERVICE, 1951. On a cloudy, cool day in July 1951, Jack and Eldora left their respective homes and traveled to Long Pine, Nebraska, where they were baptized in the chilly water of Pine Creek. Soaking wet and shivering, Jack was introduced to Eldora near the banks of the coldest spring-fed creek in Nebraska.

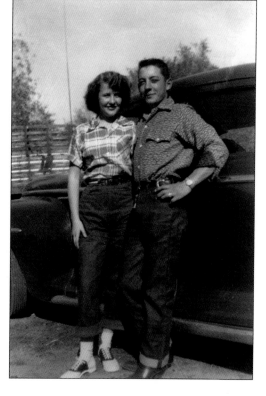

THE YOUNG COUPLE, 1951. Jack and Eldora grew up with much in common, though they did not meet until they were in their teens. Both attended one-room schoolhouses, though in different towns. Both were active in their churches. Jack was president of his youth group at Bassett Assembly of God Church; Eldora led the youth group at Ainsworth Assembly of God Church. Their lives centered on faith and family.

JACK VETTER, 1951. At church camp in Lexington, Nebraska, about 150 miles from home, Jack and Eldora attended a service to raise money for a missionary in Africa. When the offering plate was passed, Eldora watched as Jack opened his wallet. He had two $1 bills and one $5 bill. Jack put the $5 bill in the missionary offering, with complete faith the couple would have enough cash to make it home safely. "I knew right then he was my kind of guy," Eldora said.

MILES TO GO, 1953. As Jack and Eldora got to know each other, their friendship blossomed into love. Their courtship included many church functions, where they made lifelong friendships.

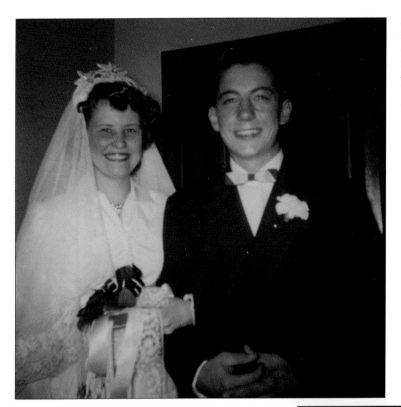

MR. AND MRS. JACK VETTER. Jack and Eldora were married June 6, 1954, on a warm, sunny day in Ainsworth, Nebraska.

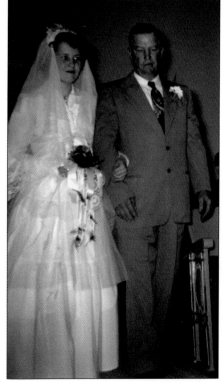

WEDDING DAY, JUNE 6, 1954. Herman Arent walks Eldora down the aisle, a special tradition for fathers and daughters. Eldora wore a white satin dress she made with help from Jack's mother. Her veil was borrowed, and the church was decorated with flowers picked from the blooming snowball trees.

FIRST APARTMENT, 1954. Now a married man, Jack left his ranching job for better pay as a custom blacksmith in Bassett, Nebraska. He earned $8 a day. After three years as a secretary for attorneys in Ainsworth, Nebraska, the new Mrs. Vetter left her first job and took a position with the Bassett Chamber of Commerce. It turned out to be the only job for which she ever applied—opportunities always awaited her.

NO EXPERIENCE IS EVER WASTED. With the wisdom of hindsight, Jack and Eldora believe their lives were shaped to prepare them for what God had planned. But as they went about the business of raising a family, volunteering at church, and earning a living, the couple had no way of knowing how they were being readied for their life's work.

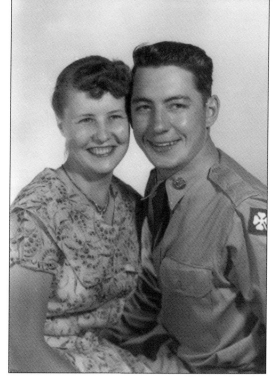

LEESVILLE, LOUISIANA, 1957. In 1956, Jack was drafted into the US Army, where he served as a heavy equipment machinist in the Engineering Division. He and Eldora relocated to Louisiana until Jack deployed to Verdun, France.

DENITH (DENNY) DEAN VETTER, 1958. When he returned home in 1958, Jack had a wife and seven-month-old son waiting for him. Denith Dean Vetter was born April 26, 1958.

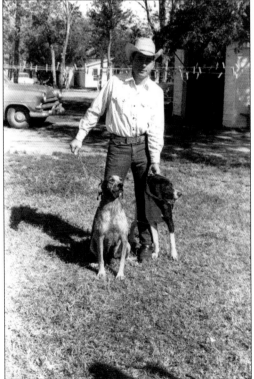

WORKING FROM THE HEART. From 1954 to 1974, Jack worked steadily in positions of increasing responsibility. He continued to develop his skills as an innovative thinker and problem solver. Whatever the job, Jack performed it with dedication and honesty. He is pictured here with his coonhounds.

19

JACK OF ALL TRADES, 1959. Jack's early jobs included working as a custom blacksmith, building custom hay mowers, doing repair work at Bassett's International Harvester dealership, selling cars at Bassett's Ford dealership, managing the yard at Ainsworth Livestock Market, and working at a feed mill and fertilizer plant.

ARMY WIFE AND WORKING MOM, 1960. As Jack developed his skills, Eldora also continued to grow personally and professionally. While working at the Bassett Chamber of Commerce, she was approached by the owner of a local bank with a job offer. Eldora worked at the bank for three years before moving to Fort Polk, Louisiana, after Jack completed basic training. She returned to Bassett when Jack deployed to France. Eldora is pictured here holding Denny and newborn Vicki.

COMPLETING THE FAMILY. In a few years, Jack and Eldora's family grew. Vicki Lynn Vetter was born on March 25, 1960, and Todd DeWayne Vetter arrived on December 10, 1962. Pictured here from left to right are Todd, Vicki, and Denny in 1964.

A NEW CAREER PATH. Jack was hired as the administrator for Pine View Manor nursing home in Valentine, Nebraska, in 1965. He and Eldora moved to Valentine in 1966. This was the beginning of Jack's work with the elderly. To educate himself, he relied heavily on the Nebraska Health Care Association, hearing fellow administrators talk about staffing hours, cost per patient day, and Medicaid reimbursement. In 1968, an opportunity came Jack's way. He accepted the position of director of operations for Bethesda senior care centers in Omaha, Nebraska.

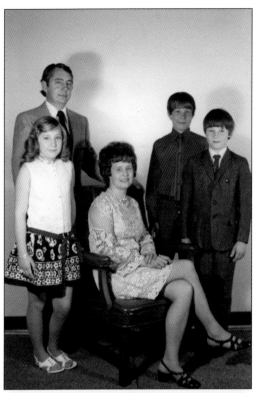

THE VETTER FAMILY, 1969. When the Vetter family moved to Valentine, Nebraska, in 1966, Eldora also worked at Pine View Manor nursing home, doing payroll and secretarial work. After moving to Omaha in 1968, she sold Avon door-to-door in the evenings from 1969 until 1978, with about 100 customers on her route. Pictured here from left to right are Jack, Vicki, Eldora, Denny, and Todd.

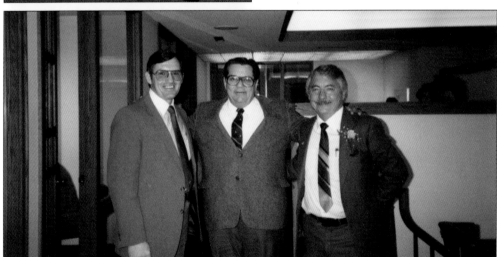

AN OPPORTUNITY ARISES. While working as Bethesda's director of operations, Jack (right) got to know Wayne Field (center), who owned three nursing homes in Nebraska. In 1974, Wayne decided to sell the homes, and asked Jack to consider buying Heritage of Fairbury in Fairbury, Nebraska, for $9,250 per bed ($888,000). Jack was interested but did not know how he could finance such a large purchase. Then he received the offer that changed the course of his life. Wayne asked for a down payment of $28,000 and told Jack he would carry the loan for 25 years at an incredible nine percent interest rate. It was the opportunity of a lifetime. Jack's honest, straightforward way of doing business had convinced Wayne to help his friend become a business owner. Also pictured here is Chet Frey (left), a friend and colleague who purchased Wayne's facility in Geneva, Nebraska.

HONEY, I BOUGHT A NURSING HOME TODAY. After they went to bed, Jack shared the news with Eldora, who did not get much sleep that night. Soon after, she visited Fairbury and saw what the Vetters were getting into. The entire facility needed work. But that was not Eldora's worry; rather, it was the $888,000 debt and $28,000 down payment. Jack's plan was to seek loans from multiple sources.

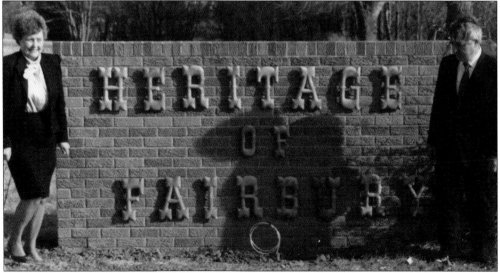

GOD'S HANDS FULL ON PURPOSE. "I don't often bargain with God," Eldora recalled. "But I was desperate. [I said,] 'Lord, I need some guidance and assurance. If this is Your will, then I want those bankers to lend Jack the full $28,000.'" A few hours later, Jack returned with news that Fairbury State Bank had offered to loan him the entire down payment. On January 1, 1975, it was official. Jack and Eldora took ownership of Heritage of Fairbury.

BRANCHING OUT. Jack and Eldora worked double time to get their new business off the ground. Jack continued to work full time for 18 months at Bethesda to insure steady income, while Eldora managed the books at Fairbury from home during the day and continued to sell Avon on the evenings and weekends. Jack was chief maintenance and repairman on nights and weekends; Eldora gave it her decorating touch. The Vetters embraced a personal mission to give facility residents a place to feel respected, secure, comfortable, and happy. This took root as Vetter Health Services focus on *dignity in life*.

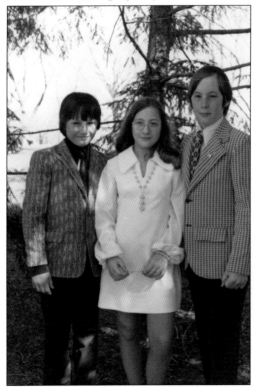

THE VETTER CHILDREN, 1975. The Vetter children (from left to right), Todd, Vicki, and Denny, grew up helping their parents and grandparents and volunteering at church. The family spent many weekends together sprucing up the first facility, Heritage of Fairbury. In the winter of 1975, Jack, Eldora, and their three teenagers put 30 gallons of paint on the walls at Fairbury.

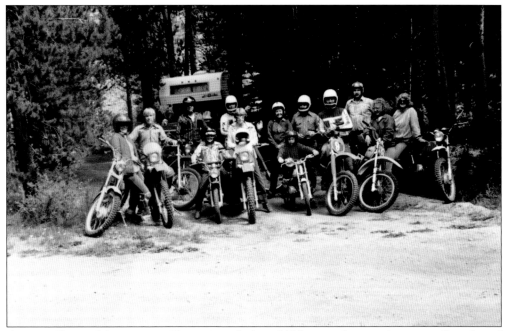

ANNUAL FAMILY MOTORCYCLE TRIP, 1980. Jack and Eldora made sure it was not all work and no play. The Vetter family enjoyed camping, hunting, fishing, riding motorcycles, snowmobiling, and simply spending time together whenever they could. This photograph shows the family motorcycling in the Rocky Mountains of Colorado.

WORK HARD, PLAY HARD. In this photograph, Vetter sons Todd (left) and Denny playfully threatened to throw Jack into the ocean during a family outing. Jack and Eldora recognized the importance of striking a balance between work and play—at home and on the job. Having fun together is as essential as hard work to fulfilling the Vetter Health Services mission. Sharing moments of laughter with co-workers, taking time out to enjoy family and friends, and savoring the small successes all make Vetter Health Services team members happier at home and more effective at work.

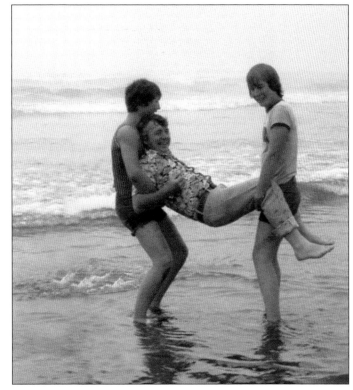

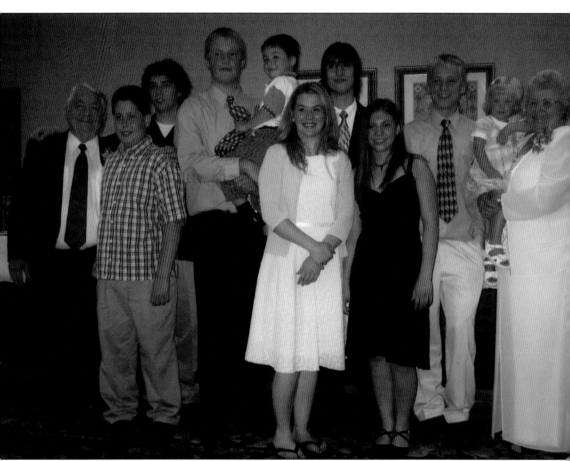

THE VETTER GRANDCHILDREN, 2004. From left to right are Jack, Tynan (12), Tristan (17), Jacob (18), Dalton (4), Revonna (20), Jace (17), Shaye (14), Caleb (16), Karlee (2), and Eldora. From the beginning, Jack and Eldora believed that one thing matters most: relationships. Strong connections between people create work and home environments that are filled with life, love, and happiness. As the years passed, they realized that when they did what they loved, work worked itself out. With their enduring love, they hoped this philosophy would be passed onto their children and grandchildren.

Two

YEARS OF LEARNING, YEARS OF GROWTH

Therefore whoever hears these sayings of Mine, and does them, I will liken him to a wise man.

—Matthew 7:24

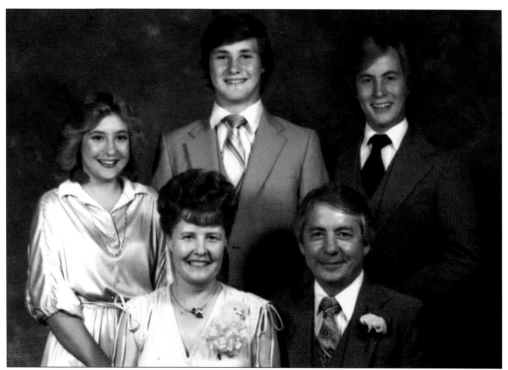

YEARS OF GROWTH, 1975–1988. These years of opportunity, learning, and growth occurred at a pace that secured financial strength, even though cash flow was tight. The VHS belief that "if we can't create world class with what we have, we will not be able to create world class with what we want" began to take root. Jack and Eldora put their own touches on every facility they purchased, often making improvements with their own hands. Their children, (from left to right) Vicki, Todd, and Denny, also contributed in many ways to VHS success, pitching in wherever help was needed, from painting walls to working in the home office. All three currently serve on the VHS board of directors.

HERITAGE OF FAIRBURY, 1975. This facility in Fairbury, Nebraska, was the first purchased by the Vetters. Jack was 40 years old at the time. It offered private and semiprivate rooms, rehabilitation services, activities, transportation, and a beauty/barbershop, along with short-term stays to help residents regain independence. "To truly believe that I was going to walk in on January 1 and start the operation, it had to be the most satisfying thing that ever happened to me," Jack said.

CLOVERLODGE, 1976. This facility in St. Edward, Nebraska, was the second VHS purchase; one of the home's residents is pictured here. A month earlier, Jack had resigned as Bethesda's director of operations to devote his full attention to Fairbury and St. Edward. During negotiations to purchase Cloverlodge, Jack asked if the owner's van could be added to the deal. "She looked over at me and said, 'Jack, if you use it for the residents I'll throw it in,'" he recalled.

VHS Established, 1977. In the early years, Jack and Eldora's primary mission was providing quality care. They focused their energy on creating facilities that functioned well and offered safe, pleasant surroundings. As they gained experience, their focus expanded beyond providing quality care to the all-encompassing mission of providing quality life. Systems and specialization were developed to support the vision. In 1977, Vetter Health Services was established as the management company. Jack Vetter (right) is pictured here with friend and attorney Steve McGill.

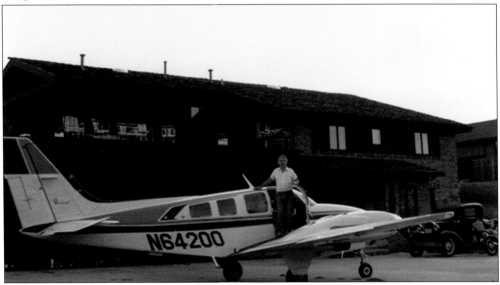

Jack Vetter Learns to Fly. From 1979 to 1984, Jack and Eldora operated Vetter Health Services from their home on Sky Park Drive in Omaha. The house included the VHS office and an airplane hangar in the lower level. Jack obtained his pilot's license in 1969 as a way to shorten commute times between home and work; throughout his career, he logged more than 7,500 hours in the air. Jack is shown here with his 1982 Beechcraft Baron B58P.

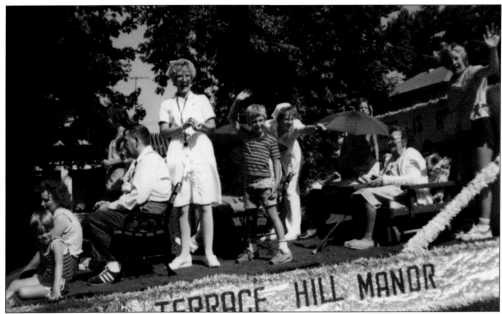

HERITAGE OF EMERSON, 1979. Heritage of Emerson, originally named Terrace Hill Manor, is located in Emerson, Nebraska, a small town of approximately 800 people in the rolling hills of northeast Nebraska. Emerson is named for poet Ralph Waldo Emerson and is near the larger neighboring cities of Sioux City, Iowa; Wayne, Nebraska; and Norfolk, Nebraska. Here, residents, team members, and family members represent the facility in a local parade.

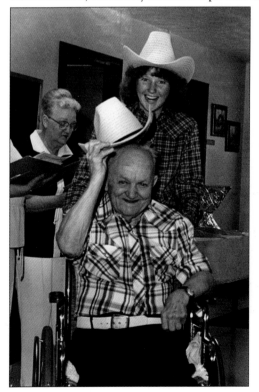

HOWDY, PARTNERS. Themed activities and spontaneous merrymaking take place regularly within VHS facilities and the communities they serve. Residents, team members, and neighbors are encouraged to let loose and have a little fun, as shown in this photograph of a Heritage of Emerson event.

HERITAGE ESTATES, 1980. This skilled nursing facility is located in Gering, Nebraska, between the Colorado Front Range, Yellowstone National Park, and Mount Rushmore. Nestled at the base of Dome Rock and Scotts Bluff National Monument, Heritage Estates offers residents breathtaking views. In 1999, two memory care neighborhoods were added; in 2006, a new facility replaced the original.

HERITAGE CARE CENTER, 1981. This VHS acquisition is located in Iowa Falls in north central Iowa. Known as the "Scenic City," Iowa Falls is a picturesque town with the beautiful Iowa River running through it, and boasts parks, several tourist attractions, and other amenities. In 1987, VHS invested in an addition to the Iowa Falls facility. Residents are encouraged to share their gifts and talents, filling the facility with music and good will.

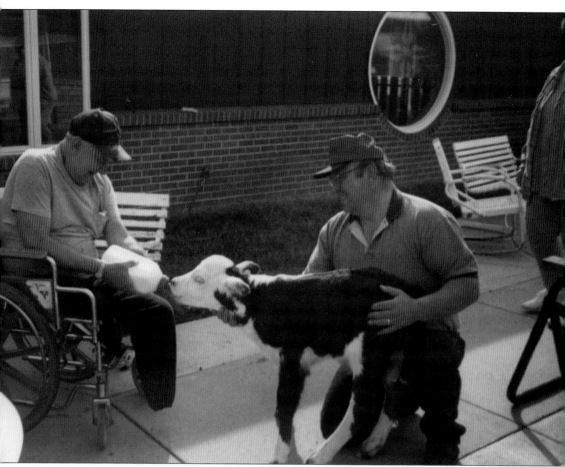

DAVID PLACE, 1982. This skilled nursing and rehabilitation facility is located in David City, Nebraska, a farming community of approximately 2,500 located about an hour from Omaha and Lincoln, Nebraska. Services offered include occupational, physical, and speech therapy. In 1999, updates included the addition of more resident rooms, a large dining area, and multipurpose rooms.

HERITAGE LIVING CENTER OF ST. PAUL, 1982. This nursing home in St. Paul, Nebraska, was purchased along with a nearby home that was later licensed as an assisted living residence. Heritage offers skilled nursing, rehabilitation, memory, respite, and hospice care, along with occupational, physical, and speech therapy.

HERITAGE OF BEL-AIR, 1982. Located in Norfolk, Nebraska, this skilled nursing facility features secure memory support neighborhoods for those with Alzheimer's disease; restorative nursing care; physical, speech, and occupational therapy; and hospice care.

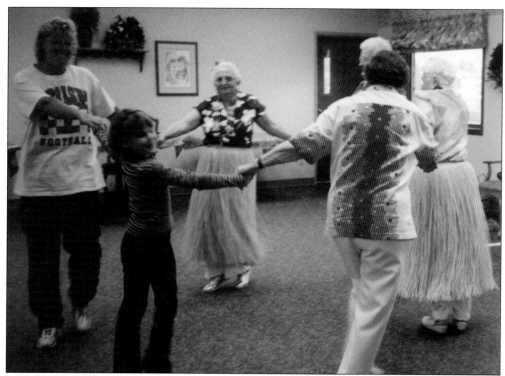

HULA AT HERITAGE OF BEL-AIR. Bringing the generations together at Heritage of Bel-Air is a surefire recipe for fun, laughter, and general silliness that puts a swing in the step of folks of all ages. Updates in 1994 added more beds and a new dining room. Additional improvements later that year introduced a chapel and another residence wing. A third addition was completed in 2005.

HERITAGE OF RED CLOUD, 1983. This VHS facility is located in the city of Red Cloud, Nebraska, which was home to author Willa Cather, best known for her depictions of frontier life on the Great Plains. This quaint facility is nestled in the south central part of Nebraska.

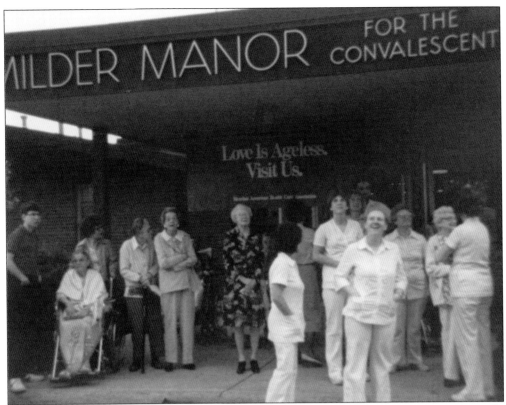

MILDER MANOR/SUMNER PLACE, 1984. This skilled nursing facility in Lincoln was originally named Milder Manor for the Convalescent. Renamed Sumner Place by VHS, the new identity signaled a shift in long-term care philosophy. Sumner Place's location in the state capital of Lincoln helped VHS influence and shape legislation affecting the industry. Major renovations in 2013 continued to enhance resident care.

VHS FIRST OFFICE BUILDING, 1985. Vetter Health Services built and moved into its first office building, located in Omaha, in 1985.

NEW HOME OFFICE, 1985. The VHS team moved to new offices at 5010 South 118th Street in Omaha. At this time, Eldora Vetter was corporate treasurer, Tom Klug was director of operations, Denny Vetter was assistant director of operations, Jim Mabrey was accounting supervisor, and Julie Knobbe was promoted to administrative assistant. Todd Vetter, a college student at the time, ran errands and helped out wherever he was needed.

MANY HAPPY RETURNS, 1984. Jack Vetter celebrated the big 5-0 on July 25, 1984, with family and friends at Omaha's Walnut Grove Park. While 50 marked the end of a half century of living, it was also the start of a new chapter—a time to start afresh, seek new opportunities, and put valuable experience to use.

10TH ANNIVERSARY, 1985. On November 1, 1985, VHS celebrated a decade of service since the purchase of its first facility. During the party, Jack presented Wayne and Maria Field, from whom he had bought his first nursing home, with a trip around the world. Jack recalled, "Wayne had agreed to carry back a good portion of the financing. After we closed the deal, he said, 'Jack, when you make your first million you can buy me a trip around the world.' At our 10th anniversary I shook his hand and handed him an envelope with trip details."

LINDEN MANOR, 1985. Purchased in 1985, in 1998, VHS replaced Linden Manor skilled nursing facility in North Platte, Nebraska, with Linden Court, a new facility where events and activities for all ages bring the generations together and help keep families close.

HAVEN HOUSE, 1985. This skilled nursing facility in Wahoo, Nebraska, was replaced in 2004 when VHS built a new facility, South Haven.

Golden Heights Living Center, Garnett, Kansas. This VHS facility has been completely remodeled to provide residents with progressive, short-term rehabilitation and skilled nursing, along with memory, respite, and hospice care. VHS purchased the then-vacant nursing facility in 1985 and opened it a year later after an extensive construction phase. In 1994, upgrades to Golden Heights increased the number of licensed beds; renovations to the west wing were completed in 2010. Here, a team member takes a moment to take in the day with a resident.

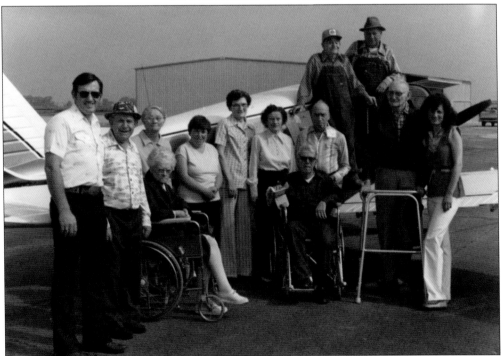

Heritage Crossings, Geneva, Nebraska, 1986. In 1986, Jack purchased Heritage Crossings in Geneva, Nebraska, from his longtime friend and colleague, Chet Frey. After Jack purchased the facility, Chet remained on and served as the administrator. Chet (left) is pictured here with residents and team members from Heritage Crossings, where plane rides were once among the activities offered. In 2002, a major renovation and an assisted living wing were added to the facility.

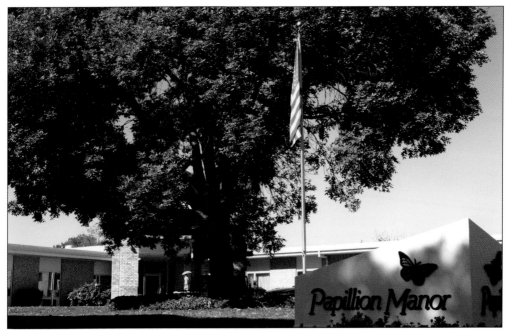

PAPILLION MANOR, 1986. After acquiring this Papillion, Nebraska, facility in 1986, VHS renovated the property in 1993, expanding the licensed beds and adding several private rooms. In 2005, a major upgrade included the addition of a memory support household. As Jack recalls, after receiving word that the property was on the market, he visited Papillion Manor and was impressed by what he saw. It was well run, clean, and polished. Buying the facility meant taking out a mortgage on their house, but Jack and Eldora worked it out, and the deal was completed.

WESTWARD HEIGHTS, 1987. VHS assumed management responsibilities for this Lander, Wyoming, nursing facility, which was owned by a local nonprofit corporation. Services included long-term care, rehabilitation, and respite care, along with memory care and outpatient therapy services; resident amenities included deluxe private rooms and beauty and barber services.

VILLAGE MANOR, 1988. After acquiring Village Manor in Lincoln in 1988, VHS in 1994 built an addition that expanded the dining room, added a chapel, and increased the number of private rooms. Jack recalled that the original facility was in need of work. "When we got it we just started the slow process of remodeling it from the inside out. From day one I said to the people I was working with, 'You can make this look like a doll house. Don't think about what it doesn't have. Every time we do something we will do it very well.'"

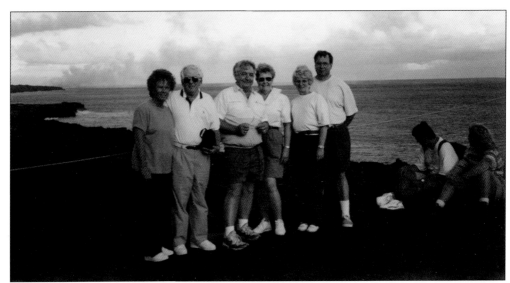

ZAIGA MORIARTY AND BERNIE DANA. Friendship and family bonds are formed among many VHS team members, who are known to travel together for fun, education, and the chance to get away and "think outside the box." Zaiga Moriarty was hired in 1985 as operations coordinator; she was promoted to operations supervisor in 1987. In 1996, she was named director of facility operations, and retired in 2007. Bernie Dana was hired in 1988 as VHS vice president and served as executive vice president and director of administrative services and special project consultant before leaving the company in 2001. Zaiga and Tom Moriarty, Jack and Eldora Vetter, and Suzie and Bernie Dana are shown in this working vacation photograph, taken on an Alaskan cruise.

TIFFANY SQUARE, 1989. The years 1989 to 1999 marked the beginning of an era that saw new facilities designed and built while acquisition of facilities continued. The vision of providing quality care and quality of life continued to drive every action and decision. VHS opened its first newly constructed skilled nursing facility, a 60-bed property in Grand Island, Nebraska. An addition in 1996 increased the number of licensed beds. Enhanced therapy and additional resident accommodations were among the 2007 improvements, followed by renovation to the common area in 2014.

WHEATRIDGE PARK, 1989. This facility, a private-pay nursing home in Liberal, Kansas, was vacant when VHS purchased it in 1989. Many upgrades were completed, and the building was re-licensed in 1991. Later, an exterior courtyard was creatively converted to a dining room expansion that now provides community space for residents, their families, and VHS team members.

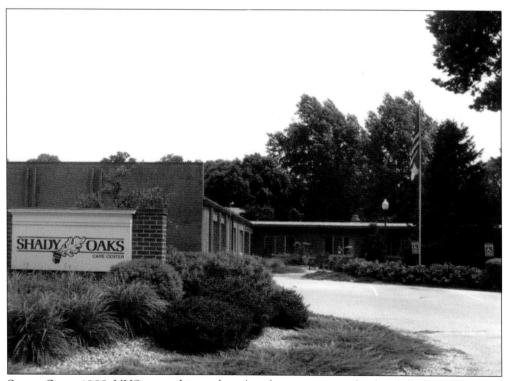

SHADY OAKS, 1989. VHS entered into a lease/purchase agreement for this skilled care facility in Lake City, Iowa, exercising its option to purchase in 1994. A heating and cooling upgrade and exterior upgrades in 2009 continued to enhance this facility.

HIGHLAND PARK CARE CENTER, 1989. Personalized rehabilitation helped Highland Park in Alliance, Nebraska, earn a prestigious Quality Life Award in 1993. VHS built the skilled nursing home in 1989 to replace an out-of-date facility operated by the Sisters of St. Francis. During a 1992 addition, a stained glass window from the original chapel was installed in the new space. "It's just been a great relationship with the community and the Sisters," Jack said.

HOOPER CARE CENTER, 1992. Providing residents with the opportunity to learn new skills or continue to pursue favorite hobbies—such as woodworking, as shown here—reinforces the VHS belief that long-term care does not mean giving up favorite activities. When Hooper Care Center, located in Hooper, Nebraska, was purchased, Jack said it exemplified what VHS wanted its facilities to be, offering a sense of family that is difficult to define but readily apparent upon walking in the door.

MANOR OF ELFINDALE, 1992. This facility in Springfield, Missouri, was the third newly constructed VHS residence. The 60-bed skilled nursing home featured 44 private rooms adjacent to the Creekside Retirement Community, which was acquired by VHS in 1998. In 1993, a major addition increased the capacity to 66 beds and enabled all rooms to be made private. This construction also included a nurses' station, a larger center section, and private dining. A second major renovation in 2004 included a memory support addition; in 2013, a state-of-the-art rehabilitation gym and chapel were added.

CREEKSIDE, 1998. The beautiful Creekside Retirement Community in Springfield, Missouri, includes a senior living apartment building with adjacent duplexes for independent living. This campus was originally managed by Vetter Health Services under a lease with option to purchase. VHS exercised this option, and Creekside at Elfindale became a permanent part of the VHS family in 2008.

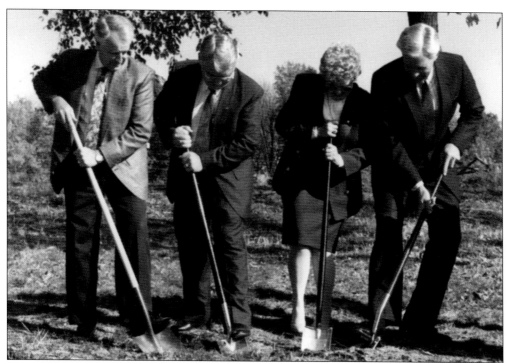

IMPORTANCE OF RELATIONSHIPS. Jack's belief in the power of relationships helped make Manor of Elfindale a reality. The owner of a senior living campus in Springfield, Missouri, asked Jack to consider building a new long-term care facility nearby. However, there was a major roadblock: another builder was expected to contest the plan. After discussions with Jack, the builder offered no objections. Pictured at the ground breaking ceremony are, from left to right, Howard Stancer, from whom VHS purchased the land, Jack and Eldora Vetter, and former State Senator Dennis Smith of Springfield.

STANTON CARE CENTER, 1993. This facility in Stanton, Iowa, features rocking chairs on the porch and beautifully landscaped courtyards. The scale of the building contributes to its walkable-community status. Stanton Care Center services are suited to residents' individual needs, providing them with an environment in which to nurture one another and enjoy life—whether on land or water, as illustrated in this field trip photograph.

47

CLOVERLODGE RENOVATIONS. The care community in St. Edward, Nebraska, has experienced significant improvements over the years. In 1994, updates included a new dining room, expanded team member break area, remodeled bathing spas, and room upgrades. Additional interior touches were made throughout the facility in 2007. For a small care community in small-town Nebraska, Cloverlodge has kept up with the times in creating a home away from home for its residents.

ROSE LANE, LOUP CITY, NEBRASKA, 1995. Lending an occasional hand in the preparation of fresh, delicious meals helps residents feel at home at Rose Lane in Loup City, Nebraska, as well as at other VHS facilities. Here, residents are shucking corn on the cob, a summer delicacy. VHS purchased this facility and completely remodeled it immediately after the paperwork was signed. An assisted living addition was completed in 2002.

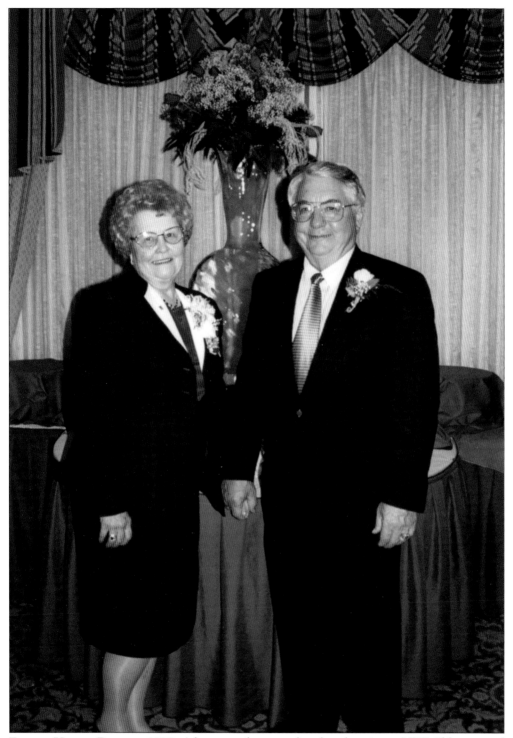

ELDORA VETTER RETIRES, 1998. After more than two decades of service to VHS, Eldora retired in 1998 from her official duties. Far from slowing down, she continues to play an important role on the board of directors and participates in long-term decisions.

Mission
"Dignity In Life"

Vision

Quality Life
We will create a living environment that radiates love, peace, spiritual contentment, dignity, and safety, while encouraging personal independence.

Quality Care
We will dedicate ourselves to provide personalized care and services that achieve extraordinary results and exceed the expectations of those we serve.

Excellent Teams
We will select and develop team members who radiate warmth, compassion, and respect while skillfully performing their duties.

Outstanding Facilities
We will develop buildings and grounds that enhance quality life and are recognized as attractive landmarks in their community.

Quality Reputation
We will be known for promoting relationships of trust, confidence, and loyalty through the quality of our services, the honesty of our people, and involvement in our community.

Stewardship
We will be responsible stewards of our resources to serve our residents, ensure the long-term financial stability of the company, reinvest in our people and facilities, and pursue growth opportunities.

DIFFICULT DECISIONS. As in every family, there were goodbyes along the way as some VHS properties were sold to new owners. Always a learning process, each of these difficult decisions was made with the big picture in mind, considering how best to position VHS to fulfill its mission in the new millennium.

Values

Serving
We succeed by focusing our attention and energies on anticipating and exceeding people's expectations. Our actions are driven by a "Yes, I Can" attitude and the commitment that we are "Family Serving Family".

Integrity
Our relationships, services and decisions will speak for our desire to always act with honesty, fairness, and compassion. People learn from interacting with us that they can trust us to be who we say we are and do what we say we'll do. We strive to act in a way that will make God smile at our efforts.

Teamwork
Our relationships are built on mutual trust and respect. We recognize the value and worth of each person we are privileged to encounter, work with, and serve. We seek to understand what is important to others and let people know they are appreciated for who they are and what they do.

Excellence
We continually pursue opportunities to improve ourselves and the services we provide. We learn from our experiences, build on our successes, and make changes when changes are beneficial. We develop people's strengths and remain committed to becoming the Best of the Best.

Vetter Health Services
www.VetterHealthServices.com

Three

CHANGING THE VIEW OF LONG-TERM CARE

Give, and it will be given to you. A good measure, pressed down, shaken together and running over, will be poured into your lap. For with the measure you use, it will be measured to you.

—Luke 6:38

STRENGTH IN NUMBERS. Today, Vetter Health Services manages over 30 locations served by more than 3,500 team members who are challenged to continuously explore uncharted paths to excellence that are consistent with the VHS mission, vision, and values. During the past decade, VHS has grown as a management company and a resource for its facilities. It has begun providing specialized care to residents with dementia. VHS skilled nursing facilities became Medicare certified, and a greater focus was placed on rehabilitation.

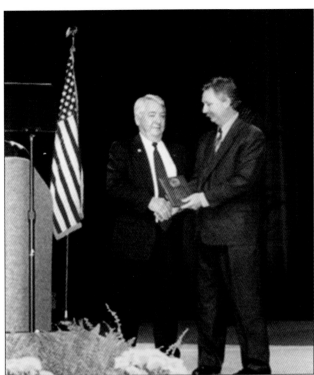

LEADERS IN QUALITY CARE.
In 2001, the American Health Care Association awarded Jack its first prestigious Friend of Quality Award, now known as the Mary K. Ousley Champion of Quality Award. It is given to an individual or organization that has made a significant national contribution to advancing quality performance in the long-term care field. Recipients must consistently advocate for quality approaches while demonstrating the ability to lead, develop, promote, and implement initiatives that improve quality of life.

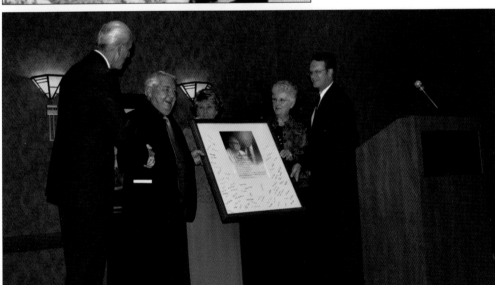

A NEW STANDARD. Today, Vetter Health Services facilities are known as leaders in providing personalized, resident-centered, high-quality care. Industry leaders, politicians, and even competitors come to observe and learn how VHS provides exceptional care. VHS team members are encouraged to nurture relationships with others in the industry, with the belief that communication and connections help raise the overall level of excellence. Every newly hired VHS team member also signs a team pledge that underscores the all-important role of the individual in providing quality care and contributing to the overall success of the VHS mission. This framed version of the team pledge was presented to Jack Vetter, whose vision inspired it.

BROOKESTONE VILLAGE, 2000. Brookestone Village was the first new skilled care community to successfully progress through the certificate of need process in Omaha in more than 30 years. The "caring households for seniors" concept was a new approach in both operations and architecture to providing quality life and quality care for residents. This pioneering care community focused on resident-centered care and involved rethinking every team member position. The building incorporated the bring-food-to-the-people (rather than people-to-the-food) strategy in dining, which remains a key quality of life and quality of care initiative today. A major renovation in 2012 added space for 20 additional residents, plus a therapy gym.

ASSISTED LIVING AT HERITAGE CROSSINGS, 2002. The Vetter development team worked collaboratively with the forward-thinking community of Geneva to create an assisted living option attached to the skilled care community. This 18-apartment addition allowed Heritage Crossings to provide options for housing and care for residents of Geneva and the surrounding areas. The combination of assisted living and skilled nursing enhanced the spectrum of care that the team at Heritage Crossings could provide. As of 2014, plans were under way for additional senior living.

ROSE COURT, LOUP CITY, NEBRASKA, 2002. The Rose Court assisted living addition was part of an innovative grant program developed by the state of Nebraska in an effort to encourage the care of residents in the most appropriate setting. Combined with the creation of a memory support household, the assisted living addition gave the Rose Lane care campus a broad spectrum of options for residents of Loup City and the surrounding area.

LINDEN ESTATES, 2003. VHS purchased this facility, which included assisted living and independent living cottages; in 2005, additional cottages were built. This retirement community in North Platte, Nebraska, provides the ultimate in choice for residents who desire carefree living. From two-bedroom cottages with fireplaces and back porches to fine dining in the lodge, residents have the opportunity to live life abundantly in relationship with others. Among the services offered at Linden Estates is temporary respite care, provided to people with disabilities so their families can take a break from the daily routine of caregiving.

SOUTH HAVEN, 2004. This new, state-of-the-art VHS facility in Wahoo, Nebraska, replaced the original building. South Haven is a wonderful collection of care neighborhoods connected by a Main Street concept for the public spaces. Residents have many activity choices, including socializing in their quiet neighborhoods, gathering for coffee or ice cream, or enjoying quiet worship in the Main Street chapel.

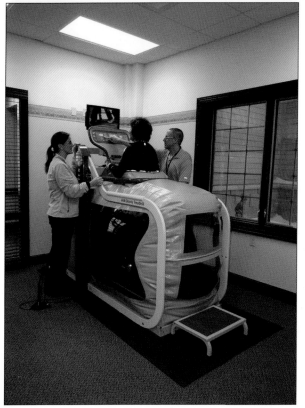

NEW OPPORTUNITY, 2004. On his way to work one summer morning in 2004, Jack heard a radio news report about a local hospital discontinuing its subacute rehabilitation service. Later, he learned of changes at two other health care facilities. Together, the information added up to an opportunity for VHS to open a new facility and develop a new area of expertise in subacute rehabilitation.

GAINING NEW SKILLS. In order to put Jack's idea in motion, team members had to acquire the skills and expertise to provide short-term rehabilitation with a focus on helping patients return home. It did not happen quickly or easily, but it was a goal worth reaching for. Brookestone Meadows Rehabilitation & Care Center in Elkhorn, Nebraska, opened in the fall of 2007 and quickly became the area leader in subacute rehab.

HERITAGE OF BEL-AIR, NORFOLK, NEBRASKA, 2005. This addition to the facility enhanced the private room offerings for residents at Heritage of Bel-Air. The clinical work space, training, and team member support areas were also reimagined. The addition—the third for this VHS facility—reinforced the idea that *dignity in life* applies to both residents and team members.

PAPILLION MANOR, 2005. Since the 1990s, this neighborhood campus in Papillion, Nebraska, has undergone upgrades and major additions to expand resident care options. Memory support, short-term rehabilitation, and therapy services were all strengthened through this comprehensive approach to development. Papillion Manor has truly become a landmark in the community.

HERITAGE ESTATES, 2006. The replacement of a tired nursing home originally designed around a 1960s hospital model of care became the motivation for the development of Heritage Estates in Gering, Nebraska. This connected household concept was a further refinement of the resident-centered plan that had been developed six years earlier. The building was expressed as a refined lodge set at the base of the Scotts Bluff National Monument. The connected households were organized to capture the beauty of the monument views in this historic setting.

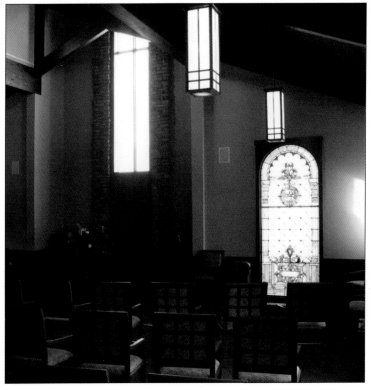

A PLACE TO WORSHIP. This chapel in Heritage Estates of Gering, Nebraska, is an example of the many beautiful chapels that are found in every VHS care center. Many of the stained glass windows were purchased from old churches that were being torn down. The chapels provide a place for residents, families, and team members to gather for weddings, funerals, and other milestone events, as well as for quiet worship.

Brookestone Meadows, 2007. Phase I of the new facility in Elkhorn, Nebraska, was designed to meet the needs of those patients requiring short-term rehabilitation and skilled nursing services. In 2008, Phase II improvements included additional space for long-term care residents and short-term rehabilitation services.

Ridgewood Rehabilitation and Care Center, 2008. Purchased as two aging, adjacent long-term care facilities in Seward, Nebraska, Ridgewood's contract included a pledge to renovate the campus or build a replacement facility. The phased-in upgrades and construction of the new building were completed in 2014.

HOME OFFICE BUILT AND RELOCATED, 2009. VHS relocated from Omaha to a new office building in Elkhorn, Nebraska, that includes conference and meeting areas designed to foster learning and strengthen relationships between team members.

SHADY OAKS, 2010. Environmental comfort for residents was the motivation for renovation of this central Iowa care community in Lake City. Every square foot of the building was refined, upgraded, or otherwise beautified. The sprinklers were repositioned, and the air conditioning was upgraded to a larger capacity, significantly improving and enhancing the quality of life for residents and their caregiving team. Interior and exterior updates transformed Shady Oaks into a place residents could comfortably call "home."

GOLDEN HEIGHTS LIVING CENTER, 2010. Over the past 25 years, a consistent remodeling and updating strategy at Golden Heights Living Center in Garnett, Kansas, has kept the VHS quality of life vision in the forefront. Key areas of focus include enhancements to the dining environment and resident room upgrades.

SOUTHLAKE VILLAGE REHABILITATION AND CARE CENTER, 2011. A newly constructed VHS facility replaced Village Manor in Lincoln in 2011. The skilled nursing and short-term rehabilitation facility, with space for 126 residents and patients, features state-of-the-art technology, including mobile resident charting, which allows clinicians to capture data at the bedside. This real-time tracking greatly improves accuracy, decreases errors, and streamlines the entire care process. Physicians can access patient information from any location on a moment's notice, decreasing paperwork and increasing time with patients and families.

A STROLL DOWN MAIN STREET. Southlake Village is designed around the connected household, relational model of care. The scale of the space, the furnishings, and the resident-centered amenities found within each household support the essence of home and reinforce the resident-caregiver relationship. Resident households are connected by Main Street, which reinforces the historic context of the Lincoln community. Building facades within Main Street resemble buildings listed in the National Register of Historic Places. The intimacy of the household spaces supports quality of life, while the Arts and Crafts style and the historical context of Main Street contribute to the unique experience for residents, families, and team members.

BROOKEFIELD PARK, 2013. A year and a half of excitement and hard work culminated in one incredible day, Monday, July 8, 2013, when residents and team members in St. Paul, Nebraska, were welcomed to a spectacular new replacement facility at 1405 Heritage Drive. Their original location, Heritage of St. Paul, was purchased in 1982 and later replaced. The new location, now named Brookefield Park, offers unique "household" settings designed to support the physical, emotional, and lifestyle needs of each resident. In contrast with outdated medical models, these residences provide a more intimate environment where the VHS concept of "family serving family" is truly realized. Cozy cottage interiors, along with bright and airy open spaces, evoke a hometown atmosphere complete with building styles that echo this area's farming heritage. The new campus was designed to kindle memories of peaceful strolls down a country lane or stopping by a local café to sip lemonade with family and friends.

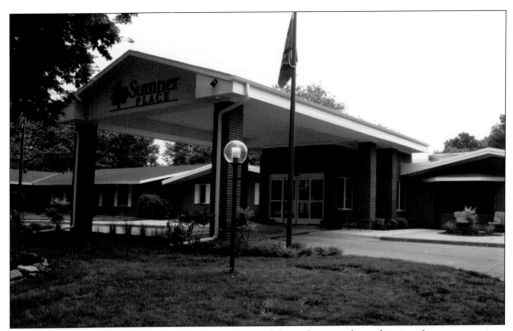

SUMNER PLACE, 2013. This care community near south Lincoln went through a significant revamping, which affected nearly every space within the building. The transformation earned the team the Neighborhood Beautification Award from the Near South Neighborhood Association in Lincoln. Located in a historic section of Lincoln, Sumner Place is truly a special place for its residents.

MANOR OF ELFINDALE. This facility in Springfield, Missouri, saw a major upgrade in 2004 that included a memory support addition; in 2013, a state-of-the-art rehabilitation to the gym and chapel was completed. The addition and updates highlighted the VHS vision for quality care and quality of life. This expansion included a therapy gym for short-term rehabilitation and a chapel to enhance the spiritual lives of residents.

TIFFANY SQUARE RENOVATIONS, 2007, 2014. Improvements at Tiffany Square expanded short-term rehabilitation offerings to this Grand Island, Nebraska, community. The project included private rooms, a new dining room, serving kitchen, and therapy gym, all designed to enhance the short-term rehabilitation experience.

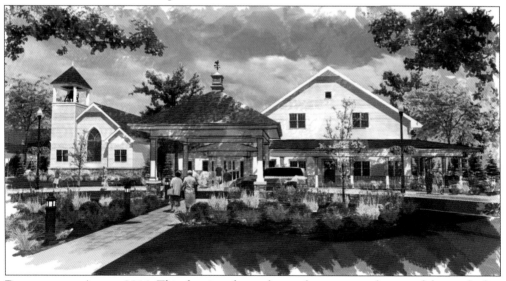

BROOKESTONE ACRES, 2014. This drawing shows the newly constructed, state-of-the-art facility in Columbus, Nebraska, which offers skilled nursing and short-term rehabilitation services. The "farmhouse" architectural theme for this care community contributes to the sense of home for its 80 residents. Wraparound porches and access to quiet, landscaped courtyards add to year-round enjoyment of nature; the chapel, with its stained glass window and bell tower, enhances the spiritual quality of life.

BEAUTY AWAITS. The road to building Brookestone Acres was long and arduous. In 1990, VHS submitted a proposal to construct the new facility. It was denied in 1994 after state officials ultimately refused to recognize the need for additional nursing home beds as mandated by certificate of need (CON) legislation. Subsequent amendments to the law and changes to the political landscape allowed VHS to meet CON requirements. In 2014—24 years after the original VHS request—Jack Vetter's dream became a reality. He dedicated Brookestone Acres on July 25, 2014, his 80th birthday.

PASSING THE LEADERSHIP TORCH. This era saw many changes in the leadership team as roles expanded and new people came on board to help take the well-respected Vetter Health Services to the next level of excellence. Jack continues to serve as chief executive officer, and he and Eldora hold leadership seats on the board of directors along with their children, Denny, Vicki, and Todd. Whether helping shape high-level policy or pitching in with day-to-day operations, Jack and Eldora's faithful involvement is a continued source of pride and appreciation among the VHS team. The Vetters' unwavering commitment to the VHS mission of *dignity in life* remains an inspiration.

GLENN VAN EKEREN NAMED PRESIDENT. Hired in 1999 as director of administrative services, Glenn Van Ekeren was promoted the following year to executive vice president while maintaining his role as director of administrative services. A decade later, he was appointed president of Vetter Health Services. Glenn has a long history of involvement with the American Health Care Association, including serving on the national board of governors. He was previously the director of people development for 20 years at Village Northwest Unlimited in Sheldon, Iowa, which provides privacy, dignity, and purpose for adults with disabilities.

MITCH ELLIOTT, CHIEF DEVELOPMENT OFFICER. Hired in 1993 as VHS corporate architect, Mitch Elliott was promoted to director of facility development in 2000. He was named chief development officer in 2009. Prior to joining the Vetter team in 1993, Mitch was a partner in the architectural firm of RDG Schutte Wilscam Birge. He also served as an intern architect for Purdy & Slack Architects and Ambrose Jackson and Associates following his graduation from the University of Nebraska College of Architecture. Nearly 25 of Mitch's 32 years of architectural design experience have focused on senior living.

JOANI SCHELM, CHIEF FINANCIAL OFFICER. Joani Schelm was hired as corporate treasurer when Eldora retired in 1998; she was promoted to director of financial services in 2000, and named chief financial officer in 2009. Prior to joining VHS, Joani spent 20 years in banking as a vice president/loan officer.

PATRICK FAIRBANKS, CHIEF OPERATIONS OFFICER. After joining the Vetter Health Services team in 1987, Patrick, over the course of the next 20 consecutive years, served as the administrator of three VHS facilities. In 2007, he accepted a position as leadership development coordinator with the operations team within the VHS home office. In 2008, Patrick was named director of operations; he has served as chief operations officer since 2009.

Four

GOOD STEWARDS OF TIME, TALENTS, AND TREASURES

But as for me and my house, we will serve the Lord.

—Joshua 24:15

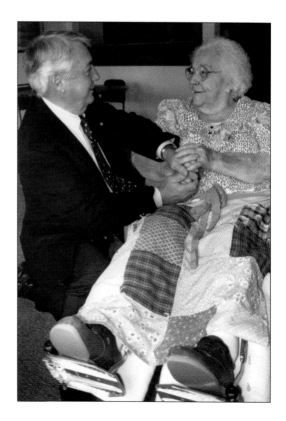

MISSION, VISION, AND VALUES. Jack and Eldora want to make each resident of VHS facilities feel like the most important person in the world. The VHS mission of *dignity in life* has been a constant since the beginning. The words to describe it have been refined over the years, but it ultimately comes back to each team member treating everyone they come in contact with as the most important person in their life. Here, Jack visits with Esther Kusek, a longtime VHS volunteer who later became a resident at Rose Lane. An active member of the facility's resident council, Esther lived at Rose Lane at the same time as her brothers.

HEART OF THE MISSION. Jack Vetter wrote the Vetter Health Services mission in the early 1980s, hoping to express his heart for the elderly and explain how he believed they should be treated. It became the foundation that would guide daily decisions for residents' care. Pictured here are Steve McGill, Bernie Dana, Mike Wilcox, and Jack and Eldora Vetter in 1985 at the first major company planning meeting.

BRINGING WORDS TO LIFE. Jack recognized that the key to providing *dignity in life* went beyond mere words. He knew that actions would bring his mission to life. He established a vision for quality care and quality of life that continues to inspire excellence. Today, VHS team members understand that it is not just the work they do, but how they do it, that creates "wow" experiences for those they serve.

GROWING VISION. Jack took his ideas about his vision directly to the people who could implement them on a daily basis: the teams caring for residents in each facility. The vision statements grew to include teams, reputation, facilities, and stewardship. All of these guide VHS team members, who are encouraged to never stop looking for ways to improve how they live out the VHS mission, vision, and values.

QUALITY LIFE. This vision statement focuses on creating an environment of love and peace. Good food, a good book, the sun shining in, enjoying an ice cream cone, or putting together a jigsaw puzzle with friends—all of these and more add up to quality life for VHS residents. Making sure these opportunities are provided is a personal mission for every team member.

71

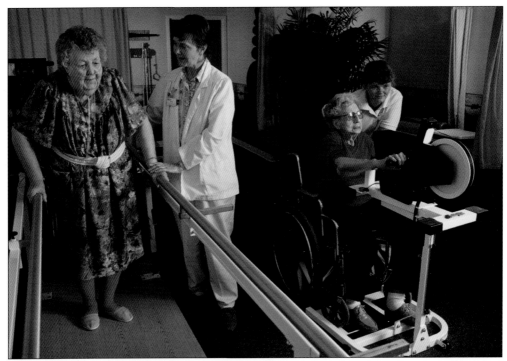

QUALITY CARE. Providing excellent care is the cornerstone of everything, but it is only part of what it takes to give VHS residents true quality of life. From the beginning, Jack and Eldora knew that the little things are not so little when it comes to ensuring *dignity in life*.

QUALITY REPUTATION. This VHS vision states, "We will be known for promoting relationships of trust, confidence, and loyalty through the quality of our services, the honesty of our people, and involvement in our community." Early on, it was Jack's reputation that secured the $28,000 loan that made the first skilled facility purchase possible. As Jack says, "I'm a farm boy. I've always said that your handshake ought to be your bond, and you ought to do what you say you're going to do."

OUTSTANDING FACILITIES. The Vetter Health Services mission is for each facility to be a landmark that enhances quality of life and a premier employer in its community. Every VHS team member plays a part in reaching this goal. Rules and regulations require that certain standards be met. The VHS mission, vision, and values drive team members to go the extra mile in making facilities feel more like home. Reinvesting in VHS facilities ensures that the bar on quality is continually raised. This ongoing process provides each resident with an environment of spiritual contentment, dignity, and safety, while encouraging personal independence. Pictured here is one beautiful example, Linden Court in North Platte, Nebraska.

EXCELLENT TEAMS. Ongoing support and training provide the tools Vetter Health Services team members need to grow as people and professionals. Through leadership development and effective planning, VHS empowers the leadership at each facility to respond to the needs of residents and team members. Recognizing achievements and celebrating team successes are an important part of the process.

PAY ATTENTION. Vetter Health Services mission, vision, and values are not simply something to display on a wall and dust off every now and then—they are a benchmark of quality and a living vision that demand all team members pay attention to opportunities for growth and improvement. The goal of every VHS team member is to be invested in all they do, and to do it like no one else.

OPENING THE DOOR. One day, Jack watched a resident as she struggled to open the door to her room, the turning of the knob made difficult by arthritis. Jack immediately recognized a conflict with the VHS vision of "quality life through outstanding facilities." Soon, all of the doorknobs at the facility were replaced with lever handles. Within a short period of time, that change was made at every VHS facility. Pictured here is Neva Vetter, Jack's mother, demonstrating the new doorknobs.

INTEGRITY. Strong relationships with VHS service providers and vendors—referred to as quality partners—are the building blocks of excellence. This 35th anniversary dinner, held in 2010, celebrated partnerships based on honesty, fairness, trust, compassion, and reputation. Emphasis on these values took root early, when purchase agreements for VHS facilities were made over lunch, written on a paper napkin, and sealed with a handshake.

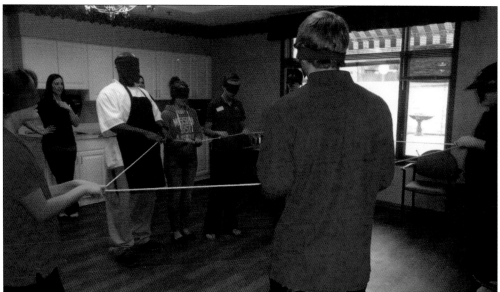

TEAMWORK. When the Vetter Health Services team is strong, residents receive the very best care. Members work hard to create teams that are committed to the VHS pledge and are excited about helping one another be successful. In this photograph, a team building exercise helps cooks and dietary aides work on communication skills. Split into two groups, the team members are blindfolded, spun around, and asked to complete a task using only verbal cues. The activity illustrates the importance of clear communication, deep listening, and depending on one another.

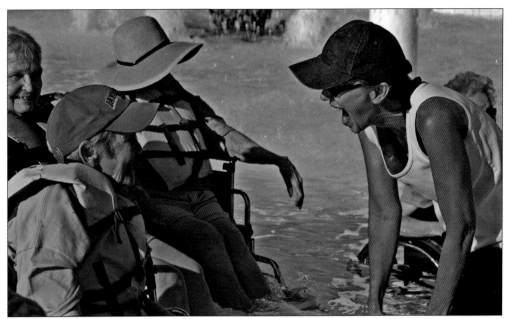

SERVING. Changing the view of long-term care requires exemplary service by all VHS team members, including exceeding expectations, treating each other as family, and developing a "yes, I can" attitude. In one example of this value in action, when Highland Park Care Center residents requested a swim adventure, the care team carefully planned to make it happen. The sensation of floating was liberating; the giggles were an unanticipated bonus therapy.

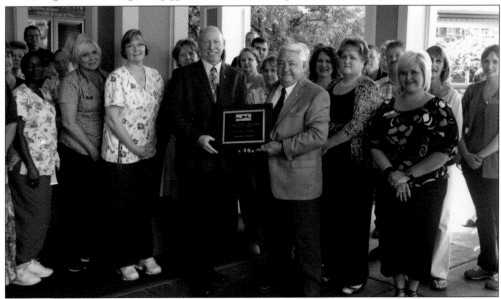

EXCELLENCE. VHS team members continually seek to improve themselves and the services they provide. They are encouraged to learn from their experiences, build on successes, and make changes when beneficial. Focusing on team members' strengths and encouraging them to develop new skills help maintain a commitment to becoming world class. In this photograph, representatives of Springfield, Missouri's, chamber of commerce present Jack Vetter and the Manor at Elfindale team with a plaque for 20 years of excellence.

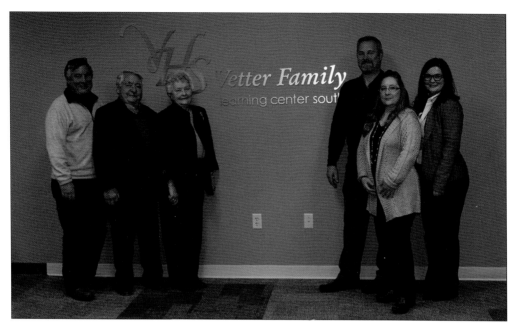

STEWARDSHIP. Investing in personal and professional growth opportunities is one of the ways VHS communicates its dedication to team members. Training and educational conferences take place in the state-of-the-art Vetter Family Learning Center at the Nebraska Health Care Association in Lincoln, which was dedicated in December 2014. Jack and Eldora are pictured here at the dedication with children Denny (far left), Todd, Vicki, and granddaughter Revonna.

USING TIME WISELY. All Vetter Health Services team members are encouraged to make choices that lead to better use of their time. For example, in 1969, Jack earned his pilot's license, which proved to be a real time-saver when traveling from facility to facility and allowed for more frequent visits. When it comes to showing a commitment to a facility and its team members, there is no substitute for being there in person. Jack's example inspired other VHS team members to earn pilot's licenses. Pictured here is Jack with his daughter, Vicki.

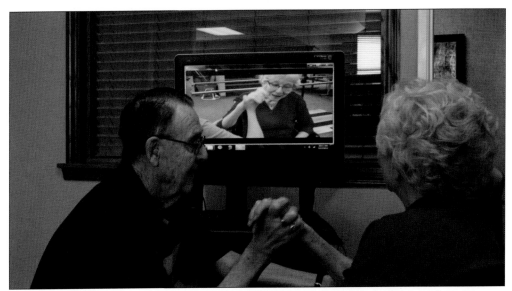

SPREADING THEIR WINGS. Some examples of recent VHS time-saving initiatives and innovations include development of a formalized operating plan, transitioning to electronic medical charting and tracking of activities of daily living, and building designs that offer enhanced care efficiencies. Another example is the popular and effective iN2L ("it's never 2 late") system, available to residents of all VHS care facilities. This computer program offers activities, social engagement, memory support, problem solving, and physical therapy tools, all based on individual abilities, interests, and needs.

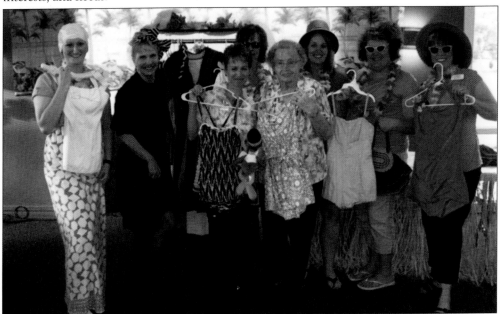

TIME OUT FOR FUN. Taking time out for themed lunches, social get-togethers, and other regularly scheduled activities outside of work promotes fun and strengthens relationships. Monthly team meetings keep lines of communication open and bring different teams together as one. This team at Heritage Care Center in Fairbury presented a show during National Nursing Home Week called "A Day at the Beach" featuring swimwear from the past.

MEMORABLE MOMENTS. Every VHS team member—including Jack Vetter, center, gets in on the fun at entertaining events that encourage laughter, high spirits, and general silliness.

25TH ANNIVERSARY, 2000. Eldora and Jack, pictured at far left and far right, were joined by Wayne Field, second from left, and Chet Frey, second from right, at the Vetter Health Services 25th anniversary celebration. Longtime friends and colleagues, Wayne had sold Jack his first long-term care facility in 1975. Later in 1986, Jack purchased Heritage Crossings in Geneva, Nebraska, from Chet Frey. The anniversary event was part of the annual VHS fall conference, held in Omaha, which also featured a celebration of the Vetter Foundation's many charitable contributions. The conference theme, "Making a Difference," was appropriate, given the inestimable difference VHS makes in the lives of thousands of residents and team members.

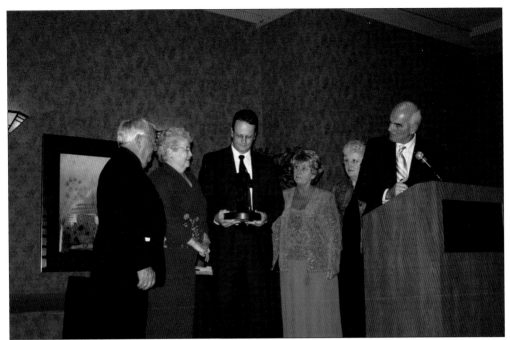

30TH ANNIVERSARY, 2005. The celebration of VHS's 30th anniversary was a highlight of the Vetter Foundation fall conference, held in Omaha. To commemorate the occasion, VHS administrators and home office team members presented Jack and Eldora with a bronze sculpture titled *Fisher of Men* in appreciation for three decades of dedicated service that influenced the lives of thousands of VHS residents and team members, creating ripple effects that helped to reshape the entire long-term care industry.

35TH ANNIVERSARY, 2010. Celebration of the 35th VHS anniversary was held in Omaha, providing an opportunity to bring everyone together to reflect on the past, celebrate successes, and think about the future.

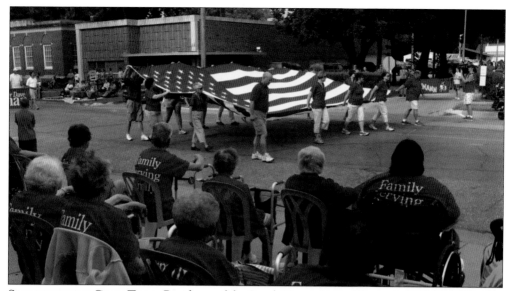

SHARING IN THE GOOD TIMES. Residents of the South Haven Living Center in Wahoo, Nebraska, sported bright "Family Serving Family" shirts to represent Vetter Health Services at a county parade. South Haven team members jumped through a number of hoops to ensure that all residents could participate, including borrowing transportation from other VHS facilities. This is an example of the VHS belief that success comes from focusing attention and energy on anticipating and exceeding expectations. Every day, team members' actions are driven by a "yes, I can" attitude and the commitment that they truly are "family serving family."

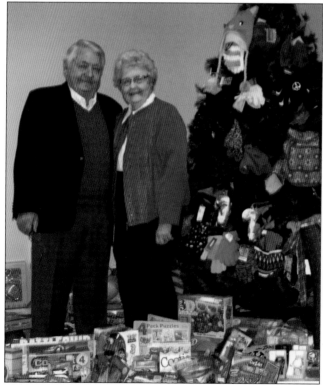

HELPING HANDS IN HARD TIMES. Showing compassion for others is one way Vetter Health Services team members lead by example. Every day, they support each other in ways large and small: listening to each other, praying for each other, and giving away personal time or vacation time when a colleague needs a few more days off. Going the extra mile, even when it is not in the policy manual, creates a company culture that honors the Golden Rule. For example, rather than giving them Christmas gifts, Jack and Eldora asked that VHS team members donate toys, gifts, and necessities to children in need. This simple request has become a beloved tradition—one that emulates and honors Jack and Eldora's year-round generosity.

HELPING OTHERS SUCCEED. Jack and Eldora love to see people grow. Their commitment to helping others succeed has led to many VHS programs that foster personal and professional development, including tuition reimbursement programs for team members, educational offerings at conferences, or serving on committees that shape health care policy.

TAKE TIME TO CARE. This ground-breaking program is designed to foster a cultural shift among VHS team members, with exercises designed to enhance relationships, build teams, refine communication skills, activate common courtesies, and enrich lives. It is designed for a maximum amount of self-discovery, with participants encouraged to apply principles and skills learned to all areas of their lives, both at home and at work. Take Time to Care helps team members understand the all-important role they play in the lives of VHS residents and among their fellow team members. Reminders about the importance of simple acts of kindness and courtesy, such as knocking before entering residents' rooms—just as they would knock before entering a home—reinforce the VHS mission of *dignity in life*. The original program materials were donated to the Vetter Foundation by Johnna Bavoso of The People Business Inc.

STRENGTHS-BASED COMPANY. As a strengths-based company, all VHS home office and facility leadership team members take the Clifton StrengthsFinder assessment upon hire. This tool measures talent and identifies potential for building upon strengths. Three certified strengths coaches provide training to all VHS team members.

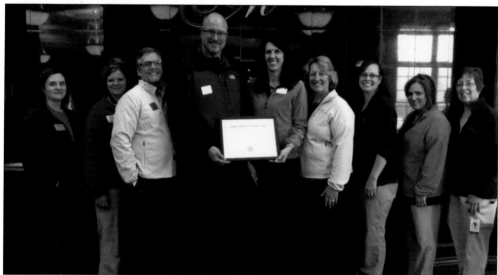

GERONTOLOGICAL CERTIFICATION. These Brookestone Meadows and Brookestone Acres team members are among many VHS nurses who are certified by the gerontological certification program, created to expand the knowledge, skills, competencies, and personal and professional growth of registered nurses in long-term care facilities. Vetter Health Services strongly promotes this program to all of its registered nurses; the percentage of VHS nurses with this certification is significantly higher than the national average among all registered nurses. VHS is passionate about continuing to raise the bar in quality care and striving for excellence. When approached by the University of Nebraska Medical Center, the Vetter Foundation jumped at the chance to participate. Initial funding for the program was provided through a grant from the Robert Wood Johnson Foundation, the Northwest Health Foundation, and the Vetter Foundation. All gerontological certification is awarded through the American Nursing Credentials Center.

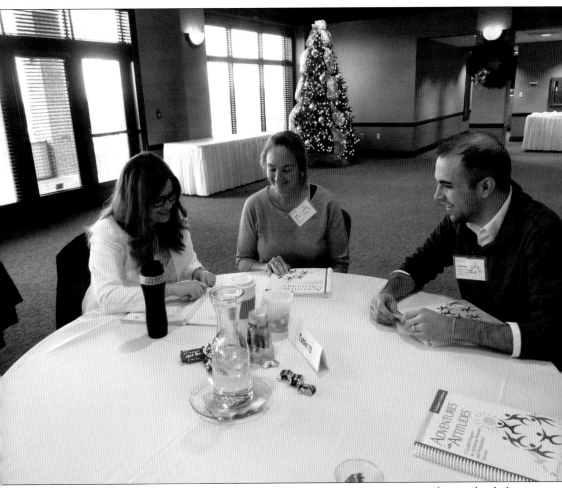

ADVENTURES IN ATTITUDES. Adventures in Attitudes is an empowering program designed to help team members understand that how they perceive and respond to events around them is their choice. Participants also gain knowledge and skills to develop and maintain positive attitudes, self-discovery, and long-term performance improvement. Vetter Health Services provides this program to company leaders once a year as a continuing educational opportunity and as a chance to build leadership skills.

BUDDIES FOREVER DEMENTIA COMMUNICATION COACHING. In the summer of 2013, with the assistance of national dementia expert Erin Bonitto of Gemini Consulting Inc., Vetter Health Services embarked on a three-year journey toward providing more comprehensive dementia care. The focus of this program is on prevention of out-of-character responses, also known as behavioral expressions in dementia, and the reduction of psychotropic medications. Team members are educated and coached in small groups to use approach, communication, and engagement techniques known to be effective with individuals who have some form of dementia.

MENTORING DO IT RIGHT PROGRAM. The VHS Mentoring Do It Right program was created to provide a welcoming environment and family atmosphere for new team members, setting them up for success the moment they join the VHS family. This program stresses the importance of mission, vision, and values, and emphasizes how a mentor should live and teach others these guiding philosophies. Mentors learn the key components of communication and how to train others based on the learning styles that fit them best. The program also helps both the new team member and the mentor build relationships with one another as well as with residents, families, and other team members.

ORIENTATION. VHS and each facility offer new team members a general orientation. Team members learn about the facility and what sets it apart from other places, along with key information about each department. Throughout the process, the focus is on mission, vision, and values. Team members come to understand that all of these aspects combined are essential to providing quality care and dignity for residents. VHS also provides job-specific orientations to team members; those in leadership positions also meet with their home office support person and attend a thorough job-specific orientation. These peer-to-peer trainings help team members build on one another's experiences and nurture relationships along the way.

CONFERENCES. Vetter Health Services believes that education is the path to growth and developing the future. Opportunities for team members range from departmental (such as nursing, maintenance, housekeeping and laundry, dietary, marketing, social services, or life enrichment) conferences to the administrator's fall conference. Each gathering is designed to meet the educational needs of various departments and address practical ways to make the VHS mission, vision, and values come to life.

REACHING BEYOND VHS. Team members are encouraged to share their time and talents beyond facility walls. A few examples of groups and organizations VHS serves include the American Health Care Association along with state health care associations in Nebraska, Kansas, Iowa, Wyoming, and Missouri. Jack first became a Nebraska Health Care Association member in 1969; since that time, he has served more than a dozen terms, holding offices including district president, chair, vice chair, and director at large. Jack also served for many years on the board of the Nebraska Health Care Foundation. In this photograph, former Nebraska Governor Ben Nelson and his wife, Marcia, are flanked by Eldora and Jack Vetter.

AWARDS AND HONORS. VHS facilities have earned dozens of industry honors, including several American Health Care Association and state Health Care Association quality awards and Edgerton Awards for quality improvement. In-house honors—such as the Bright Star Awards—are also cause for celebration. Most recently, Bright Star awards were based on submissions to the VHS intranet communication *In the Loop*, which reports on news and happenings at various care communities.

BEST PLACE TO WORK. The Best Places to Work in Omaha initiative provides an online survey to help gauge employee attitudes. According to research, engaged employees stay with their employers longer, contribute to profits, and serve customers more effectively. The annual program is sponsored by Baird Holm LLP and the Greater Omaha Chamber of Commerce. VHS was recognized in 2008 and 2009 before winning first place in 2010 as the Best Place to Work in Omaha in the midsized company category.

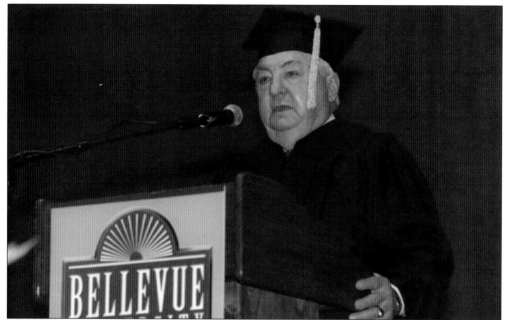

HAIL TO THE CHIEF. Some of the honors and awards given to VHS Founder Jack Vetter over the years include the first-ever National Friend of Quality Award, presented by the American Health Care Association Quality Program in 2001, and induction in the Nebraska Chamber of Commerce Business Hall of Fame in 2008. Here, Jack delivers the 2006 commencement address at Bellevue University, where he also received an honorary bachelor of science degree in commerce.

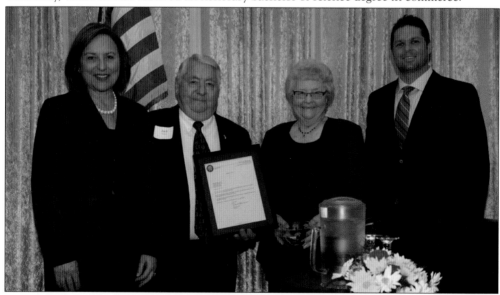

ELEPHANT REMEMBERS. In 2014, Jack and Eldora were honored at the Douglas County Republican Party Elephant Remembers event, which acknowledged their outstanding service to the GOP. The Vetters believe that relationships with elected officials and lobbyists help give VHS a voice in local, state, and national legislation affecting the long-term care profession. Presenting the award to Jack and Eldora are US Senator Deb Fischer and Bryan Baumgart, chairman of the Douglas County Republican Party.

ADDY AND TELLY AWARDS. In 2013, the Vetter Foundation and Jackson+Appleton video production received a gold ADDY award from the American Advertising Federation of the Ozarks for the Vetter Foundation video, which helps to orient new team members and provides a company overview. Honors went to VHS's DaNita Naimoli and the Jackson+Appleton production team. The video also received a bronze Telly Award, chosen from 12,000 entries from 50 states and numerous countries. Accepting the award, from left to right, are Robin Jackson, Nicholas Appleton, DaNita Naimoli, and G.N. Fowler.

RECOGNIZING ACHIEVEMENTS. Quality awards are presented annually at the Vetter Foundation fall conference. One such achievement is being rated deficiency-free by the Department of Public Health certification survey. The achievement helps prospective residents, their families, and health care practitioners make informed choices. Another honor, injury-free award celebrations, underscores the VHS commitment to safety. Facilities that mark 365 days—an incredible 8,760 hours—without an injury celebrate with a steak fry and awards.

GIVING BACK THROUGH THE VETTER FOUNDATION. In 1992, Jack and Eldora formed the Vetter Foundation as a way of showing their gratitude for the blessings they have experienced in their lives. Vetter Holding Inc. earmarks 10 percent of its earnings to fund the Foundation. The annual Vetter Foundation Golf Classic raises additional funds. The Vetters, VHS team members, and quality partners are also generous contributors. The Foundation's purpose is twofold: to support and serve people in need through local, national, and worldwide missions and organizations, and to improve the quality of education in health care by sponsoring educational opportunities.

FOUNDATION A DAILY REMINDER. The Vetter Foundation is a daily reminder to all team members that VHS reaches needs around the world. Some of the projects sponsored, funded, and co-funded by the Vetter Foundation include Convoy of Hope, Light for Lost, Assistance League of Omaha, Mobility for Humanity, One Child Matters, Open Door Mission, Water for the World, East Africa School of Theology, Africa's Hope, numerous Bible college student computer labs, the purchase and distribution of leather-bound Bibles, World War II veterans Heartland Honor Flights, Homes of Hope, Addis Ababa Bible College in Ethiopia, gerontology and leadership training, missionaries, and many, many more. Here, Eldora and Jack Vetter are pictured at the border between Kenya and Tanzania in 1992.

THE VETTER FOUNDATION

life **APPLICATION** Study Bible

a special **offer** for you

God has blessed us!

We would love to have the opportunity to bless you in return. Before we were married in 1954 we agreed to use the Bible as the standard for our lives. It has anchored us in our personal and professional lives and gives us direction every day.

With that, we are offering you the gift of a personally-signed Bible. The one thing we would ask—if you choose to receive this Bible from us you must promise to read and study it on a regular basis. It is a beautiful, large (9 1/2 by 6 1/2"), black, top grain leather New International Version Life Application Study Bible by Zondervan Publishing. If you would like to request to receive this, please indicate so by signing and returning this card to your administrator.

Warmest Regards,

Jack & Eldora

Jack & Eldora Vetter
The Vetter Foundation

YES, I would like to request a personally-signed Bible. I agree to read and study it on a regular basis.

(please print)

GUIDEBOOK FOR LIVING. Before they were married, Jack and Eldora agreed to use the Bible as a standard for their lives. It has given them direction every day and provided an anchor for their professional and personal lives. Inspired to share that wisdom with their Vetter Health Services family, they offer a life-application study Bible to team members. They hope it will also bless the lives of others.

HONORING THOSE WHO HAVE SERVED. In 2009, Vetter Health Services helped to sponsor dinners for 750 veterans and their families who traveled from Omaha to Washington, DC, to celebrate, remember, and pay tribute to their fellow soldiers. VHS also provided 50 wheelchairs that allowed disabled veterans to participate in the program.

CELEBRATING IN ETHIOPIA. In 2007, Jack and Eldora traveled to Africa to celebrate with the 10th graduating class of Addis Ababa Bible College in Addis Ababa, Ethiopia. The Vetters helped found the college in 1992.

WATER FOR THE WORLD. Providing and distributing clean, safe water to the poor of rural Kenya is a mission of the Vetter Foundation through Water for the World. Jack Vetter served as president of the board for this nonprofit organization. He developed the idea for this company after seeing women in rural areas walk for many miles carrying water to their families, and children playing in dirty water. The Foundation helped fund the purchase of custom rigs and well-drilling equipment with the capability of traveling rough and rugged terrain. To date, it has drilled more than 100 wells in mostly remote locations throughout Kenya.

INTERLACED

And surely I am with you always, to the very end of the age.

—Matthew 28:20

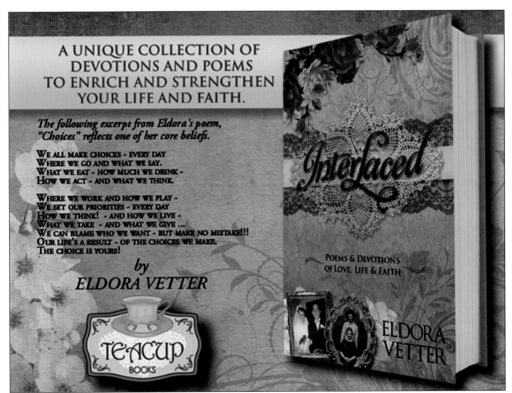

A UNIQUE COLLECTION OF
DEVOTIONS AND POEMS
TO ENRICH AND STRENGTHEN
YOUR LIFE AND FAITH.

The following excerpt from Eldora's poem,
"Choices" reflects one of her core beliefs.

WE ALL MAKE CHOICES - EVERY DAY
WHERE WE GO AND WHAT WE SAY.
WHAT WE EAT - HOW MUCH WE DRINK -
HOW WE ACT - AND WHAT WE THINK.

WHERE WE WORK AND HOW WE PLAY -
WE SET OUR PRIORITIES - EVERY DAY
HOW WE THINK! - AND HOW WE LIVE -
WHAT WE TAKE - AND WHAT WE GIVE ...
WE CAN BLAME WHO WE WANT - BUT MAKE NO MISTAKE!!!
OUR LIFE'S A RESULT - OF THE CHOICES WE MAKE.
THE CHOICE IS YOURS!

by
ELDORA VETTER

TEACUP
BOOKS

Interlaced

POEMS & DEVOTIONS
OF LOVE, LIFE & FAITH

ELDORA
VETTER

POEMS AND DEVOTIONS BY ELDORA. Over the years, Eldora has written and published dozens of poems. Some look back on her childhood, her marriage to Jack, their children, and treasured friendships. Others reveal the faith and values that have guided her life. Her first book, *Interlaced*, was published by her company, Teacup Books, in 2010. All book sale proceeds are donated to Water for the World, a charity that provides clean drinking water to the poor residents of rural Kenya. This excerpt from Eldora's poem "Choices" reflects one of her core beliefs.

DISCOVER THOUSANDS OF LOCAL HISTORY BOOKS FEATURING MILLIONS OF VINTAGE IMAGES

Arcadia Publishing, the leading local history publisher in the United States, is committed to making history accessible and meaningful through publishing books that celebrate and preserve the heritage of America's people and places.

Find more books like this at
www.arcadiapublishing.com

Search for your hometown history, your old stomping grounds, and even your favorite sports team.